This book belongs to

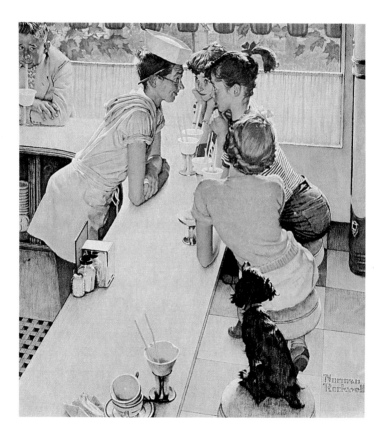

American Memories

NORMAN ROCKWELL

ARIEL BOOKS

ANDREWS AND McMEEL

KANSAS CITY

Frontispiece: AT THE SODA FOUNTAIN
Saturday Evening Post cover, August 22, 1953

Book design by Susan Hood

American Memories

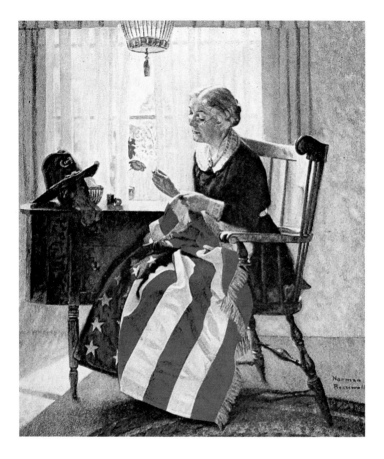

MENDING THE FLAG

Literary Digest cover
May 27, 1922

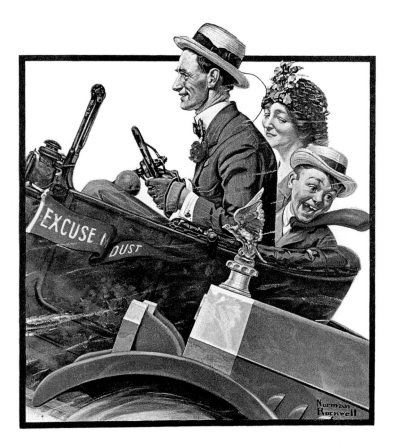

THE OPEN ROAD

Saturday Evening Post cover
July 31, 1920

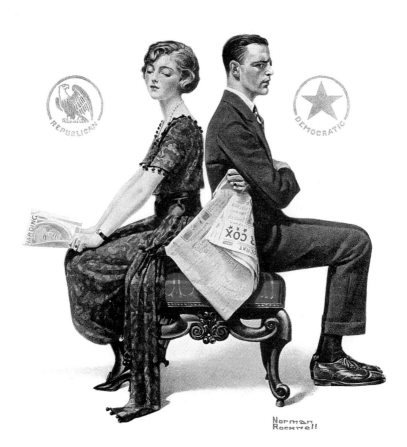

THE DEBATE

Saturday Evening Post cover
October 9, 1920

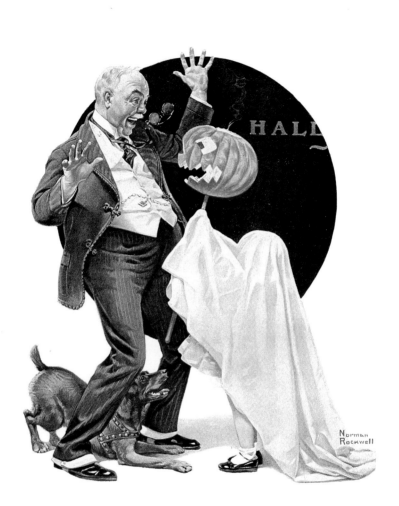

HALLOWEEN

—

Saturday Evening Post cover
October 23, 1920

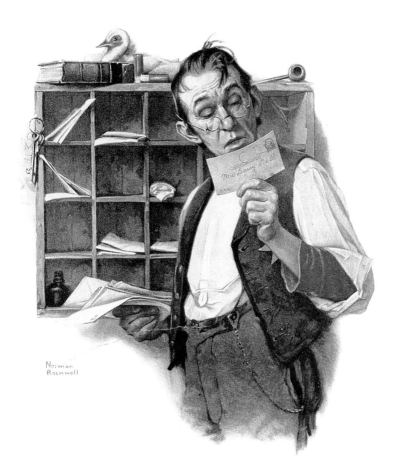

POSTCARD

Saturday Evening Post cover
February 18, 1922

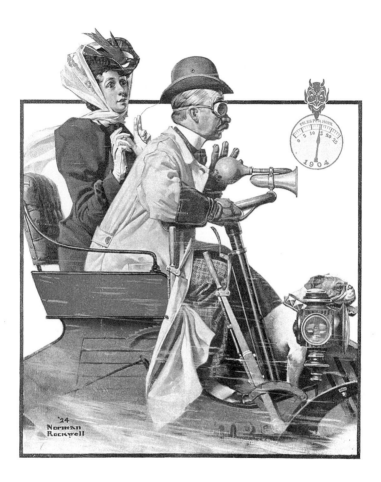

SPEED

Saturday Evening Post cover
July 19, 1924

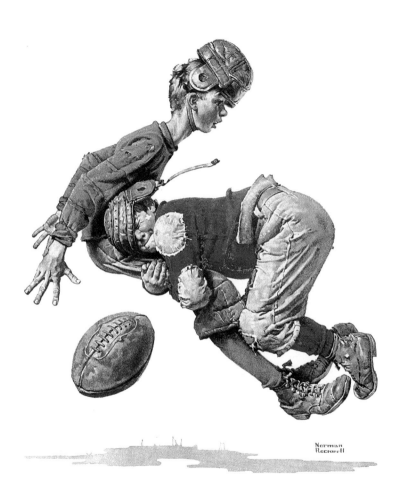

THE TACKLE

———

Saturday Evening Post cover
November 21, 1925

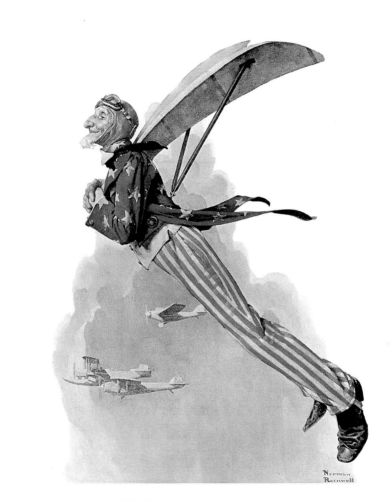

UNCLE SAM TAKES WING

—

Saturday Evening Post cover
January 21, 1928

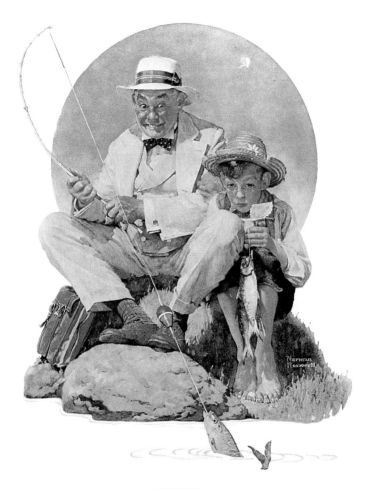

FISHING

—

Saturday Evening Post cover
August 3, 1929

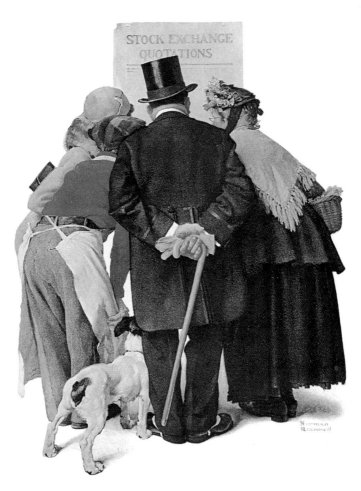

STOCK EXCHANGE QUOTATIONS

Saturday Evening Post cover
January 18, 1930

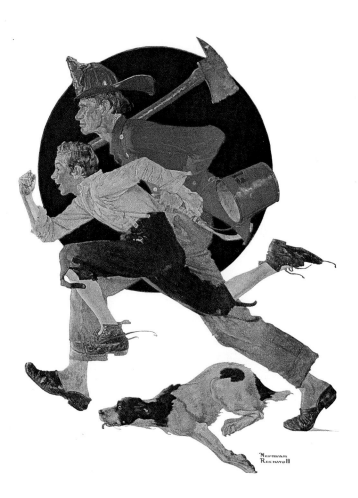

FIRE!

Saturday Evening Post cover
March 28, 1931

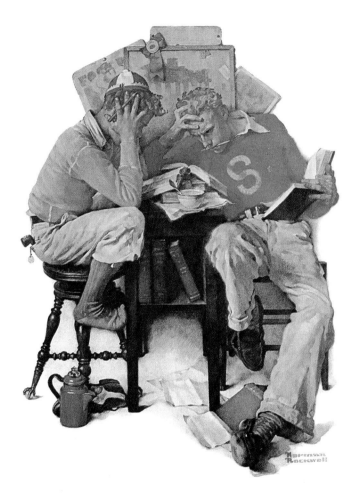

CRAMMING

Saturday Evening Post cover
June 13, 1931

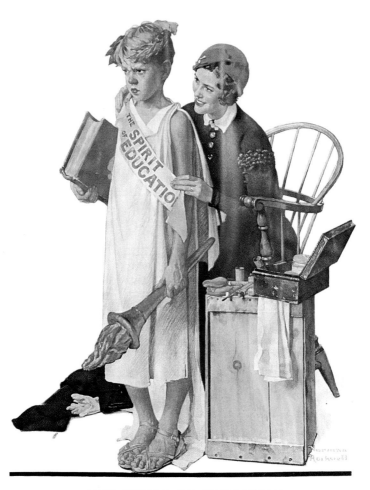

THE SPIRIT OF EDUCATION

—

Saturday Evening Post cover
April 21, 1934

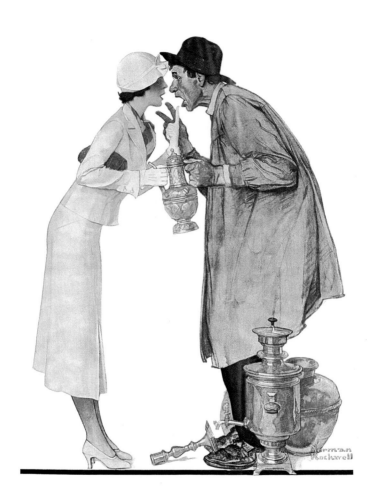

STRIKING A BARGAIN

—

Saturday Evening Post cover
May 19, 1934

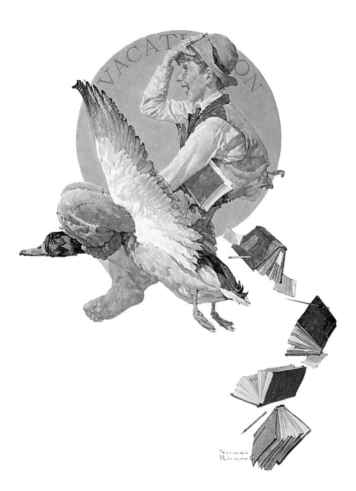

VACATION

———

Saturday Evening Post cover
June 30, 1934

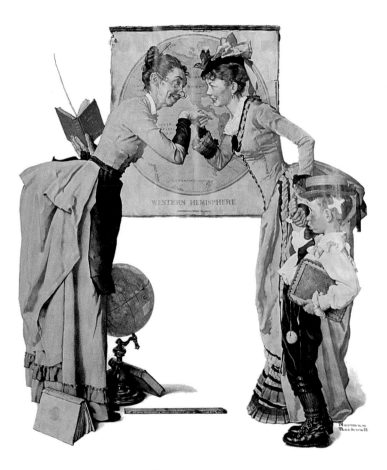

SCHOOL DAYS

—

Saturday Evening Post cover
September 14, 1935

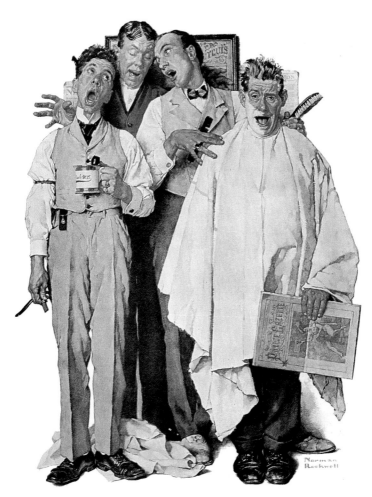

BARBERSHOP QUARTET

Saturday Evening Post cover
September 26, 1936

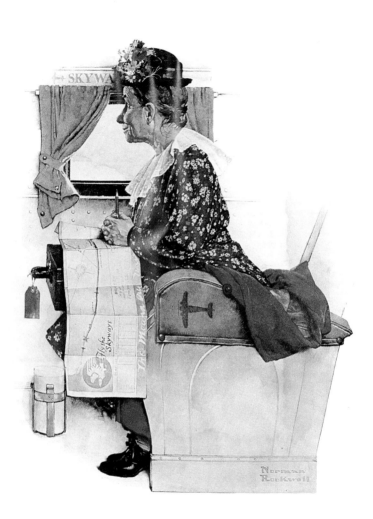

FIRST FLIGHT

Saturday Evening Post cover
June 4, 1938

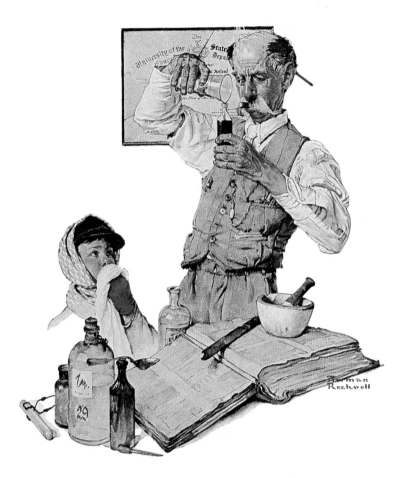

THE DRUGGIST

Saturday Evening Post cover
March 18, 1939

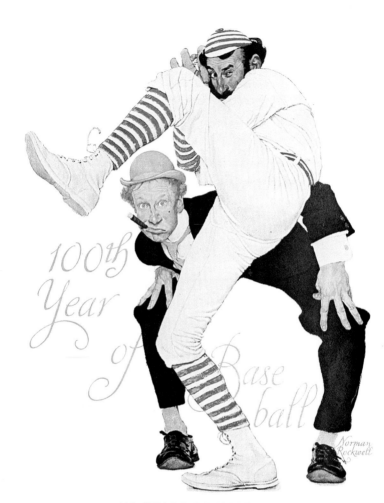

100 YEARS OF BASEBALL

———

Saturday Evening Post cover
July 8, 1939

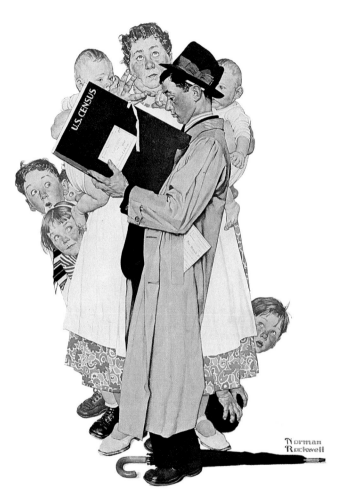

CENSUS TAKER

Saturday Evening Post cover
April 27, 1940

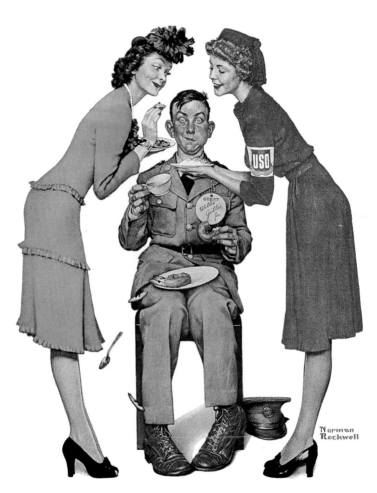

USO VOLUNTEERS

Saturday Evening Post cover
February 7, 1942

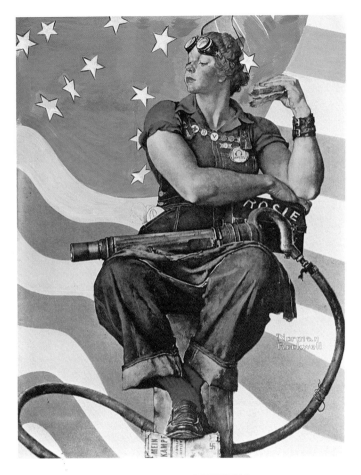

ROSIE THE RIVETER

———

Saturday Evening Post cover
May 29, 1943

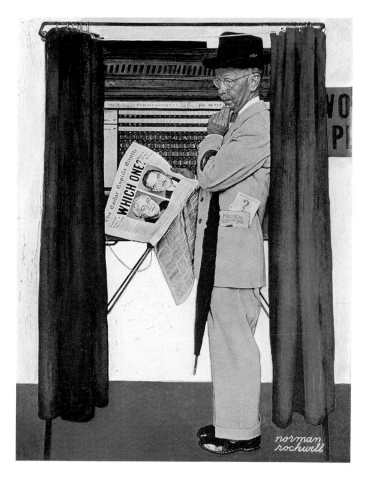

WHICH ONE?

—

Saturday Evening Post cover
November 4, 1944

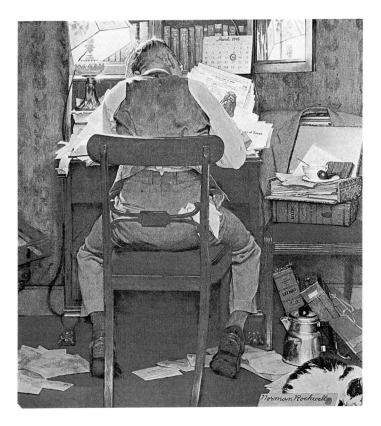

TAXES

—

Saturday Evening Post cover
March 17, 1945

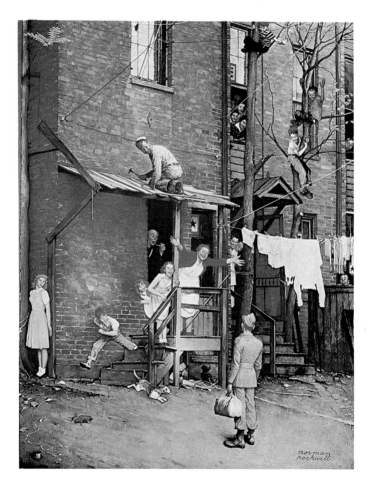

HAPPY HOMECOMING

Saturday Evening Post cover
May 26, 1945

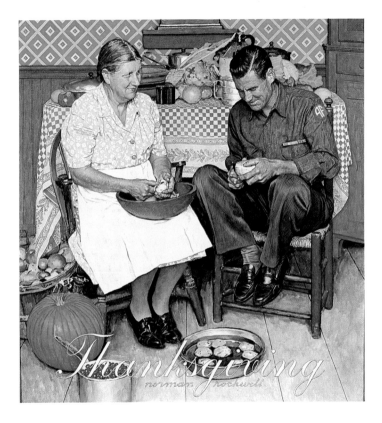

THANKSGIVING

———

Saturday Evening Post cover
November 24, 1945

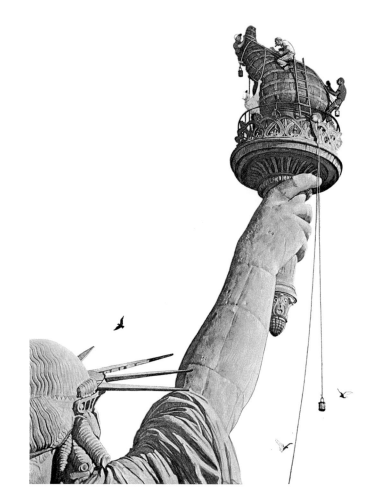

STATUE OF LIBERTY

Saturday Evening Post cover
July 6, 1946

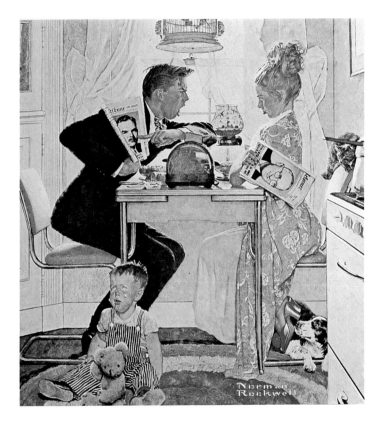

ELECTION DAY

Saturday Evening Post cover
October 30, 1948

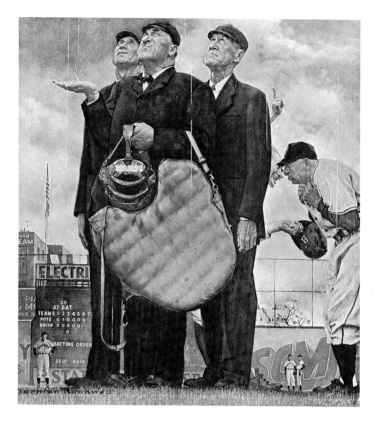

BOTTOM OF THE SIXTH

Saturday Evening Post cover
April 23, 1949

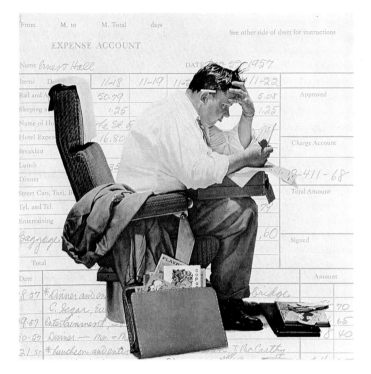

EXPENSES

—

Saturday Evening Post cover
November 30, 1957

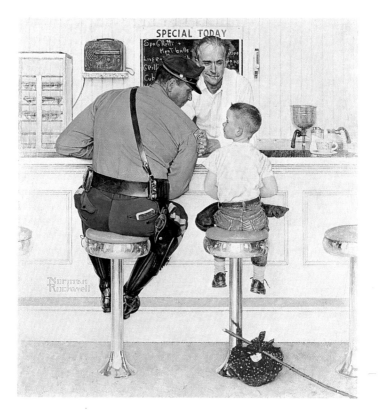

THE RUNAWAY

Saturday Evening Post cover
September 20, 1958

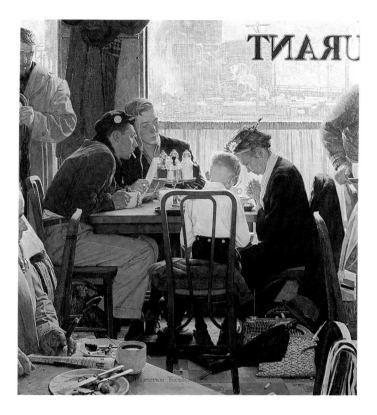

SAYING GRACE

───

Saturday Evening Post cover
November 24, 1951